A

PROGRESSIVE COURSE

OF

INVENTIVE DRAWING

ON THE

PRINCIPLES OF PESTALOZZI,

FOR

THE USE OF TEACHERS AND SELF-INSTRUCTION;

ALSO WITH A VIEW TO ITS ADAPTATION TO

ART AND MANUFACTURE.

BY

WM. J. WHITAKER,

PRINCIPAL OF THE BOSTON SCHOOL OF ART AND DESIGN, AND LECTURER
ON DRAWING IN THE MASSACHUSETTS TEACHERS' INSTITUTES.

First Course.

Copyright © 2013 Read Books Ltd.
This book is copyright and may not be
reproduced or copied in any way without
the express permission of the publisher in writing

British Library Cataloguing-in-Publication Data
A catalogue record for this book is available from the
British Library

Drawing and Illustration

Drawing is a form of visual art that can make use of any number of drawing instruments, including graphite pencils, pen and ink, inked brushes, wax colour pencils, crayons, charcoal, chalk, pastels and various kinds of erasers, markers, styluses, metals (such as silverpoint) and even electronic drawing. As a medium, it has been one of the most popular and fundamental means of public expression throughout human history – as one of the simplest and most efficient means of communicating visual ideas.

Drawing itself long predates other forms of human communication, with evidence for its existence preceding that of the written word – demonstrated in cave paintings of around 40,000 years ago. These drawings, known as pictograms, depicted objects and abstract concepts including animals, human hands and generalised patterns. Over time, these sketches and paintings were stylised and simplified, leading to the development of the written language as we know it today. This form of drawing can truly be considered art in its purest sense – the basic forms on which all others build.

Whilst the term 'to draw' derives from the Old English *dragan* (meaning 'to drag, draw or protract'), the word 'illustrate' derives from the Latin word *illustratio,* meaning 'enlighten' or 'irradiate'. This process of 'enlightenment' is central to drawing and illustration as we know it today. Medieval codices' illustrations were often called 'illuminations', designed to highlight and further explain

important aspects of biblical texts. This was the most general form of illustration; hand-created, individual and unique. This changed in the fifteenth century however, when books began to be illustrated with woodcuts – most notably in Germany, by Albrecht Dürer.

The first creative impulses of a painter or sculptor are commonly expressed in drawings, and architects and photographers are commonly trained to draw, if for no other reason than to train their perceptual skills and develop their creative potential. Initially, artists used and re-used wooden tablets for the production of their drawings, however following the widespread availability of paper in the fourteenth century, the use of drawing in the arts increased. During the Renaissance (a period of massive flourishing of human intellectual endeavours and creativity), drawings exhibiting realistic and representational qualities emerged. Notable draftsmen included Leonardo da Vinci, Michelangelo and Raphael. They were inspired by the concurrent developments in geometry and philosophy, exhibiting a true synthesis of these branches – a combination somewhat lost in the modern day.

Figure drawing became a recognised subsection of artistic drawing in this period, despite its long history stretching back to prehistoric descriptions. An anecdote by the Roman author and philosopher Pliny, describes how Zeuxis (a painter who flourished during the 5th century BCE) reviewed the young women of Agrigentum naked before selecting five whose features he would combine in order to paint an ideal image. The use of nude models in the medieval artist's workshop is further implied in the writings

of Cennino Cennini (an Italian painter), and a manuscript of Villard de Honnecourt confirms that sketching from life was an established practice by the thirteenth century. The Carracci, who opened their *Accademia degli Incamminati* (one of the first art academies in Italy) in Bologna in the 1580s, set the pattern for later art schools by making life drawing the central discipline. The course of training began with the copying of engravings, then proceeded to drawing from plaster casts, after which the students were trained in drawing from the live model.

The main processes for reproduction of drawings and illustrations in the sixteenth and seventeenth centuries were engraving and etching, and by the end of the eighteenth century, lithography (a method of printing originally based on the immiscibility of oil and water) allowed even better illustrations to be reproduced. In the later seventeenth and eighteenth centuries, the previous combination of the arts and sciences in drawing gave way to a more romantic and even classical style, epitomised by draftsmen such as Poussin, Rembrandt, Rubens, Tiepolo and Antoine Watteau. Mastery in drawing was considered a prerequisite to painting, and students in Jacques-Louis David's Studio (a famed eighteenth century French painter of the neo-classical style), were required to draw for six hours a day, from a model who remained in the same pose for an entire week!

During this period, an increasingly large gap started to emerge between 'fine artists' on the one hand, and 'draftsmen' / 'illustrators' on the other. This difference became further complicated with the 'Golden Age of Illustration'; a period customarily defined as lasting from the

latter quarter of the nineteenth century until just after the First World War. In this period of no more than fifty years the popularity, abundance and most importantly the unprecedented upsurge in quality of illustrated works marked an astounding change in the way that publishers, artists and the general public came to view artistic drawing. Arthur Rackham, Walter Crane, John Tenniel and William Blake are some of its most famous names. Until the latter part of the nineteenth century, the work of illustrators was largely proffered anonymously, and in England it was only after Thomas Bewick's pioneering technical advances in wood engraving that it became common to acknowledge the artistic and technical expertise of illustrators. Such draftsmen also frequently used their drawings in preparation for paintings, further obfuscating the distinction between drawing/painting, high/low art.

The artists involved in the Arts and Crafts Movement (with a strong emphasis on stylised drawing, and a powerful influence on the 'Golden Age of Illustration') also attempted to counter the ever intruding Industrial Revolution, by bringing the values of beautiful and inventive craftsmanship back into the sphere of everyday life. This helped to counter the main challenge which emerged around this time – photography. The invention of the first widely available form of photography (with flexible photographic film role marketed in 1885) led to a shift in the use of drawing in the arts. This new technology took over from drawing as a superior method of accurately representing the visual world, and many artists abandoned their painstaking drawing practices. As a result of these developments however, modernism in the arts emerged – encouraging 'imaginative

originality' in drawing and abstract formulations. Drawing was once again at the forefront of the arts.

There are many different categories of drawing, including figure drawing, cartooning, doodling and shading. There are also many drawing methods, such as line drawing, stippling, shading, hatching, crosshatching, creating textures and tracing – and the artist must be aware of complex problems such as form, proportion and perspective (portrayed in either linear methods, or depth through tone and texture). Today, there are also many computer-aided drawing tools, which are utilised in design, architecture, engineering, as well as the fine arts. It is often exploratory, with considerable emphasis on observation, problem-solving and composition, and as such, remains an unceasingly useful tool in the artists repertoire.

The processes of drawing is a fascinating artistic practice, enabling a beautiful array of effects and creative expression. As is evident from this short introduction, it also has an incredibly old history, moving from decorations on cave walls to the most advanced, realistic and imaginative drawings possible in the present day. It is hoped that the current reader enjoys this book on the subject.

TO

HERMANN KRUSI

(SON OF THE FIRST COADJUTOR OF THE VENERATED PESTALOZZI),

FROM WHOM I RECEIVED THE FIRST PRINCIPLES OF THIS COURSE OF INVENTIVE

DRAWING, AND TO WHOSE KINDNESS AND BROTHERLY REGARD,

I AM INDEBTED FOR MANY VALUABLE LESSONS IN

THE TRUE SCIENCE OF EDUCATION,

THIS LITTLE WORK

IS VERY AFFECTIONATELY DEDICATED BY HIS SINCERE FRIEND AND

FELLOW-WORKER,

WM. J. WHITAKER.

417 Washington Street, Boston,
Aug. 20, 1852.

DEFINITION

OF

GEOMETRICAL FORMS

USED IN THIS COURSE OF DRAWING.

An Angle is formed by the junction of two lines.

A Right Angle is obtained by drawing one straight line perpendicular on another.

An Acute Angle is that which is less than a right angle.

An Obtuse Angle is that which is greater than a right angle.

A Triangle is a space enclosed by three lines.

A Right-angled Triangle is that which has a right angle.

An Acute-angled Triangle is that which has three acute angles.

An Obtuse-angled Triangle is that which has an obtuse angle.

A Four-sided Figure is a space enclosed by four lines.

A Square is that which has all its sides equal, and all its angles right angles.

An Oblong, or Rectangle, is that which has all its angles right angles, and its parallels equal.

A Rhomb is that which has all its sides equal, but its angles are not right angles.

A Rhomboid is that which has its parallels equal, but its angles are not right angles.

A Parallel Trapezium is that which has two sides parallel and two divergent.

A Trapeziod is that which has no parallel sides.

A Circle is a curved line enclosing a space, and at equal distance in all points from the centre.

An Arc is any part of a circle.

INTRODUCTION

THE Author of this Course of Inventive Drawing addresses himself especially to the Teacher, his object being to guide him in his efforts to develop a correct power of design. This can, in his opinion, only be done by cultivating the inventive faculties, making the children produce a graduated series of figures of their own creation, thus combining a correct knowledge of form with tasteful application.

The Teacher, in placing the figures of the book before the pupils, making them objects of imitation, would miss the most interesting feature in the lessons intended to be conveyed.

Many of the illustrations in this book were designed by a class of poor children, previously ignorant of drawing. The gradual development of their powers increased their interest, and led them to discover that they could create forms surpassing all their previous irregular efforts.

A moment's consideration will show that, when correctness of eye accompanies inventive talent, the devel-

opment of better taste will introduce into our manufactures a spirit of design worthy of execution, and calculated to increase our comforts, by surrounding us with articles of utility, beautiful in their form and construction, and at very little more cost than the clumsy productions we sometimes see around us.

Drawing is essential to all good education, and eminently useful in every branch of manufacture and art. It aids the workman in carrying out the productions of the man of science, and cannot fail to make him better understand the end for which he labors.

The art of designing will be much more appreciated when, in the Primary and other schools, steps are taken to develop the fundamental principles of form in connection with correct expression and ingenuity of combination, and this will never be accomplished by copying alone.

Sir Joshua Reynolds has said, that "Copying is only a delusive kind of employment," and there appears to be much truth in the statement; for it certainly is not calculated to awaken thought or expand the mind; and employments which have not such a tendency can scarcely be called substantial or useful. It is by copying so much, and neglecting to create for ourselves, that we do not equal other nations in originality of design.

If we would be truly great in any thing, we must start from its first elements, and by gradual steps reach excellence or perfection.

Schelling, the great German philosopher, says, "Every product of art must, for the sake of clear perception, be analyzed into its separate elements, though the finished whole will represent but one harmonious idea. We then see how it rises out of the depths of our imagination, by first tracing and defining its limits, and afterwards developing an infinite richness of form, and combining them in a tasteful whole, which is presented to the soul of man."

We propose to arrange the following Lessons in Elementary Design in two courses.

The aim of the *First* will be the development of simple forms, and their elementary combinations with straight and curved lines.

The aim of the *Second* will be the development of perspective on the inventive principle, with a view to its application to the arts and manufactures.

FIRST COURSE

OF

INVENTIVE DRAWING,

BASED UPON LESSONS ON FORM.

FIRST PART.

Exercises with Straight Lines.

ALL drawing may be reduced to the simple element of the line, either straight or curved. Fig. 1.

A straight line describes the shortest distance from one point to another, and always follows the same direction.

At the first step the child must begin with the easier of the two, the straight line.

Directions of the Straight Line.

A straight line can be either vertical, horizontal, or slanting. Fig. 2.

It is important to draw from the child a clear idea of the properties of the straight line. For instance, the Teacher may hold up a string with a weight attached to it, and impress this on the children as indicating the vertical direction. By hanging the string over the black-

board, and drawing a line parallel to it, he produces a vertical line, and directs their attention to outlines of objects which follow this direction. Having clearly realized this idea, let them draw a number of vertical lines on their slates.

The horizontal direction is illustrated by the surface of water, or the equally poised beam of a balance. After the children have pointed out such lines in the objects around them, they draw a number of horizontal lines on their slates.

To illustrate the slanting or oblique line, the Teacher holding in his hand a pointer, may turn it round before the children, and, avoiding the vertical and horizontal direction, lead them to observe, that the slanting line may incline more or less to the right or left.

THE PRINCIPLES OF COMBINATION.

To combine accurately the simple lines above described, the power of drawing each correctly is acquired and augmented with the exercise.

The varying ages and capacities of the children forming the class, demand care on the part of the Teacher, in order to watch and guide their power of combination. The constructive process ought naturally to precede the analytic one; whereby we observe that a child with natural inventive faculties will sometimes create forms, incorrect in their design, whilst another of more observant

nature will abstract the outlines of existing objects without proper attention to the laws of taste. The good Teacher endeavors to modify these tendencies, and leads the one to perceive his want of accuracy; the other, his need of more taste in his conceptions.

In both, the power of defining in words the figures they have produced must be brought into play.

The youngest children will form the simplest combinations, by placing a given number of sticks on the ground in as many ways as their ingenuity can suggest. It is one of the best amusements the infant teacher can introduce, to let the children successively place the sticks, and afterwards imitate the figures thus formed on their own slates. By this exercise, the relation between a tangible form produced by the sticks, and the expression of that form by lines will be clearly developed in their minds.

We introduce here a lesson on the combination of two lines, supposing the children before us to be from six to eight years of age.

Lesson on the Combination of Two Lines.

Teacher. I wish to see two lines drawn on the blackboard; who will come and do it nicely?

Child comes and draws two lines. Fig. 3, a.

Teacher. Who can draw two lines differently?

Child may do it. Fig. 3, b.

Teacher. Now, suppose you make one line touch another? Fig. 3, d, e, f.

This the children can do in three ways, by leaving a greater or less space between the lines.

The Teacher may lead them to find some more combinations.

The Teacher having let the children exhaust these combinations, must draw their attention to the difference between each figure, and eliciting their remarks about lines at equal distances from each other, may give them the word "parallel," and apply it to all the figures where it occurs. Thus making them describe figures *a*, *b*, *c*, as two parallel horizontal, two parallel vertical, two parallel slanting lines.

The word "angle" may likewise be given to some of the combinations; and after comparing them with each other, the names "right," "acute," and "obtuse" angle. The remainder of the figures produced may also be described in a similar way.

Combination of Three Straight Lines.

The Teacher, after telling the children to place three sticks in various positions, will have such figures copied on the blackboard, and will soon obtain the following combinations, based upon the preceding ones — which are to be described by the children in the same method as mentioned in the former lesson, namely, the first four combinations

being composed of parallels, the others of different angles. (See Illustration, Fig. 4.)

The triangles produced by these three lines will elicit the remark, that now they are able to enclose a space. The difference existing between triangles must be developed, and the distinctive names applied, such as Right-angled, Acute-angled, Obtuse-angled.

A fresh and agreeable impulse may be given to this lesson, by leading the children to discover how many letters of the Alphabet may be found by the combination of three lines.

Most likely the children, and especially the less gifted ones, will produce irregular and badly executed designs; and it is important that accuracy and neatness be required. Their eye must be educated to symmetry, and the most tasteful designs held up as best, whilst the careless and disproportioned figures are only brought before the children to let them discover their defects.

The Combination of Four Straight Lines.

This combination leads to a new feature in the exercise, namely, the application of this inventive drawing to the representation of simple objects in nature. But, on entering this path, the Teacher must guard against being too severe in what might be called violation of the laws of Perspective, if the child should attempt to produce something that is meant to resemble an object. He is rather to

consider such an attempt as a rough and *unfinished*, outline that would afterwards receive a more finished appearance with the assistance of perspective brought in on a higher step.

This, however, will limit the designs of this first Course to be either the representation of rough outlines, or that of flat surfaces, rejecting all regular indication of breadth and thickness.

After having collected the most common combinations with four lines, by which some more of the letters of the Alphabet are produced, the Teacher may draw on the blackboard some figures to illustrate the object just mentioned. Fig. 5.

The quick perception of the children will discover the tendency of this hint, and will rapidly produce many other outlines of material objects, and of four-sided figures enclosing a space.

These must be particularly dwelt upon, and their respective qualities described.

Before giving the graduated series of combinations with straight and curved lines, a few hints upon the management of a large class may be acceptable to the Instructor.

HINTS FOR THE PROPER MANAGEMENT OF THE SUBJECT IN A LARGE CLASS.

The Teacher calls several children, that is, one child after another, to the blackboard; and, having specified the

combination, lets the child draw its own design. When the board is full, (which will soon be the case,) the Teacher effaces the whole, and desires the class to draw as many of the combinations as they can recollect on their own slates, together with new combinations which were not there before. After a certain time he selects off each slate the best designs, and presents them again to the whole class, having drawn them nicely upon the blackboard, pointing out why those figures are the best, and putting such questions as will illustrate the parts of the design and elicit the proper name and definition. He may also bid the children, and especially the less talented ones, copy correctly the best of the new designs.

The reward of a blank piece of paper, with permission to bring from home more and better designs, is eagerly sought for and excites a spirit of emulation and industry.

It is needless to illustrate farther lessons on the combinations to be produced by simple straight lines. The Teacher may prolong and vary such exercises according to the requirements of his class. He will possibly be more successful with little children than with older pupils, because the former enter with more of the proper spirit into this congenial mode of occupation.

Childhood is the age when the power of combination is most active. To direct its operations in systematic progression leads to their application to inventive art, and prepares the ground for original conceptions in the higher regions of the arts.

The Instructor who has the cause of Education at heart, will attribute a greater value to these exercises on combination than the mere novelty they may possess, and will upon a fair trial perceive that these elementary exercises are the necessary condition for obtaining higher results in proportion to the child's faculties; he will perceive a powerful impulse given to the class not only felt during school hours, but active everywhere in the contemplation of every work of beauty, thus forming another link in what may be termed an organic system of Education.

ANGLES.

The Teacher draws the Right, Acute and Obtuse Angles, leading the Class to a definition of all and a careful comparison of each with the others. Fig. 6. When thoroughly understood, let the pupils draw them each separately, and also in the graduated form of one within another. Fig. 7. When produced with tolerable correctness, proceed to the

Combination of Two Right Angles.
Fig. 8, a.

Here the Teacher should draw the attention of his pupils to the mode of combination, it being requisite to prevent the angles from touching each other, as it would increase the elements. We therefore divide Combination into two classes — namely, *relative* when not touching as in parallel lines, &c.; and *positive* when in absolute con-

tact. Relative combination is used in the present and succeeding exercises.

 Combination of Four Right Angles. Fig. 8, b.
 Combination of Two Acute Angles. Fig. 9, a.
 Combination of Four Acute Angles. Fig. 9, b.
 Combination of Two Obtuse Angles. Fig. 10, a.
 Combination of Four Obtuse Angles. Fig. 10, b.
 Combination of Four Right and Four Acute Angles. Fig. 11.
 Combination of Four Right and Four Obtuse Angles. Fig. 12.
 Combination of Four Right, Four Acute, and Four Obtuse Angles. Fig. 13.

TRIANGLES.

When the combinations of the angles are completed, place those triangles before the pupils which are distinguished as the right-angled, acute-angled, and obtuse angled triangles; leading them to point out their distinctive parts and qualities. Fig. 14.

 Combine Four Right-angled Triangles.
 Combine Four Acute-angled Triangles.
 Combine Four Obtuse-angled Triangles.
 Combine Four Right and Four Acute-angled Triangles.
 Combine Four Right and Four Obtuse-angled Triangles.
 Combine Four Right, Four Acute, and Four Obtuse-angled Triangles.
 Combine any number of Triangles. Fig. 15.

FOUR-SIDED FIGURES.

The Teacher, in introducing these figures, must point out to the class that their character depends on their opposite sides being parallel or divergent, and on the difference of their angles, as will be seen by comparison.

These figures when combined, may be applied to various objects, as the flat sides of buildings, wherein we allow some relaxation of the hitherto strictly observed rule of showing the parts separated, occasionally allowing them to be fitted together.

Combine Four Squares.

Combine Four Oblongs.

Combine Four Squares and Four Oblongs.

Combine Four Rhombs.

Combine Four Parallel Trapeziums.

Combine Four Rhombs and Four Trapeziums.

Combine Twelve Four-sided Figures. Fig. 16.

Combine any number of Four-sided Figures.

Combine any number of Three and Four-sided Figures.

SECOND PART OF THE FIRST COURSE.

COMBINATIONS WITH CURVED LINES.

To introduce the curved line properly, the Teacher draws it in its simplest form (the arc) on the blackboard, or slate, together with a straight line, in order to draw the attention of the children to the difference between them. They will find by observation that a straight line always proceeds in the *same* direction, describing the shortest way from one point to another, while the curved line continually changes its direction.

Again, they will see that the sides of the curved line are very different in character, being concave (hollow) on the one side, and convex (rounded) on the other, which may be exemplified by some tangible object, as a watch, glass, &c.

The Teacher may then let the pupils draw a number of arcs in different positions, in order to practise first the drawing of the line itself, and then proceed to combination.

CURVILINEAR ANGLES.

By the combination of two curved lines, three angles may be produced, the definition of which the children must be led to find for themselves, namely: the Convex,

the Concave, and the Mixed Angle — viewing their sides from the interior. Fig. 17.

 Combine Four Concave Angles. Fig. 18.
 Combine Four Convex Angles. Fig. 19.
 Combine Four Mixed Angles. Fig. 20.
 Combine Four Concave and Four Convex Angles. Fig. 21.
 Combine Four Concave and Four Mixed Angles. Fig. 22.
 Combine Four Concave, Four Convex, and Four Mixed Angles. Fig. 23.
 Combine any number of Curvilinear Angles.

The pupil should be here informed that those designs are the best and most beautiful which show simplicity in their construction, and when the conception can be easily grasped by the observer.

TWO-SIDED FIGURES.

These may be formed in two different ways, both of which must be defined by the pupils. Fig. 24.
 Combine Four Two-sided Figures, No. 1.
 Combine Four Two-sided Figures, No. 2.
 Combine Four Two-sided Figures, No. 1 and 2.
 Combine any number of Two-sided Figures.

CURVILINEAR TRIANGLES.

To supply the want of distinctive names for these figures, we number them 1, 2, 3, 4. Fig. 25.

Combine Four Curvilinear Triangles, No. 1.
Combine Four Curvilinear Triangles, No. 2.
Combine Four Curvilinear Triangles, No. 3.
Combine Four Curvilinear Triangles, No. 4.
Combine Four Curvilinear Triangles, No. 1 and 2.
Combine Four Curvilinear Triangles, No. 3 and 4.
Combine any number of Curvilinear Triangles.
Combine any number of Two and Three-sided Curvilinear Figures. Fig. 26.

FOUR-SIDED FIGURES.

When the pupils are called on to produce these figures they will soon find several of very different character, the only condition being that the four lines must enclose *one* space. The angles in this series will not always be found inside, but frequently outside; therefore we arrange them into two classes, namely —

Four-sided Figures with all their angles inside. Fig. 27.

Four-sided Figures, having part or all their angles outside. Fig. 28.

While going through this graduated course of exercises, the pupils will in all probability have acquired boldness of execution, and will naturally be induced on this step to give some of their lines a softer and more undulated appearance, which must not be checked, as it is a manifestation of correct taste. Thus a third class may be produced. Fig. 29.

As the powers of combination will have considerably increased, the Teacher may cease to limit the number of figures to be combined, making the next exercise the

Combination of any number of Four-sided Figures.

Combine any number of Two and Four-sided Figures.

Combine any number of Three and Four-sided Figures.

As a concluding Exercise, we give the combination on any number of two, three and four-sided curvilinear figures, which will well test the efficiency and progress of the pupils both in execution and design. If well directed, they will produce many combinations, rich and varied in character, considering the limited material given as a foundation, and their conceptive faculties will have received a powerful impulse in the right direction, namely, a longing for the beautiful and true, both in Nature and Art. Fig. 30.

In going through the various exercises of this elementary course, it will be requisite for the Teacher to direct his pupils to the critical examination of the various objects around, not to copy them mechanically, but to be enabled to reduce them to their primary basis, so that the mind may clearly comprehend the end for which it labors. Take for instance the Acanthus leaf, a form that most young designers stumble over without any just cause; for if it is examined with care and attention it will be found to consist only of three simple parts, which many times repeated make up the whole of that rich and classic form.

The exercises on the curvilinear angles may be prolonged at the discretion of the Teacher, and applied to various forms, such as leaves, flowers, vases, wreaths, &c.; requiring, at first, distinctness for every elemental part, and afterwards allowing them to be united, so training the pupil to correctness and clearness of application, as well as giving power to the eye and hand.

To much should never be given at once, and no lesson should be hurried over, for whatever may be apparently gained at the beginning, will only cause disappointment and trouble when on the higher steps.

Another good plan is to direct the pupils to apply the exercises given to various useful purposes, such as designs for carpets, papers, prints, embroidery, &c. These designs may never be of any real practical value for manufacturing purposes, but it will be giving to the student variety of form, &c., keenness of perception that cannot be otherwise acquired; it will lead them to observe that some forms harmonize with each other, while some do not, and also point to the necessity of walking this glorious world with open eyes, so that the mind, catching inspiration from the works of God, may ever be ashamed of producing forms at variance with the plan of the great *Artist* and *Designer* of the Universe.

THE END.

IN PREPARATION, BY THE SAME AUTHOR,

THE SECOND COURSE OF INVENTIVE DRAWING,

CONTAINING THE DEVELOPMENT AND APPLICATION OF

LINEAR AND SOLID PERSPECTIVE.

ALSO,

A SERIES OF ESSAYS

ON THE USES AND ENDS OF ARTISTIC STUDIES.

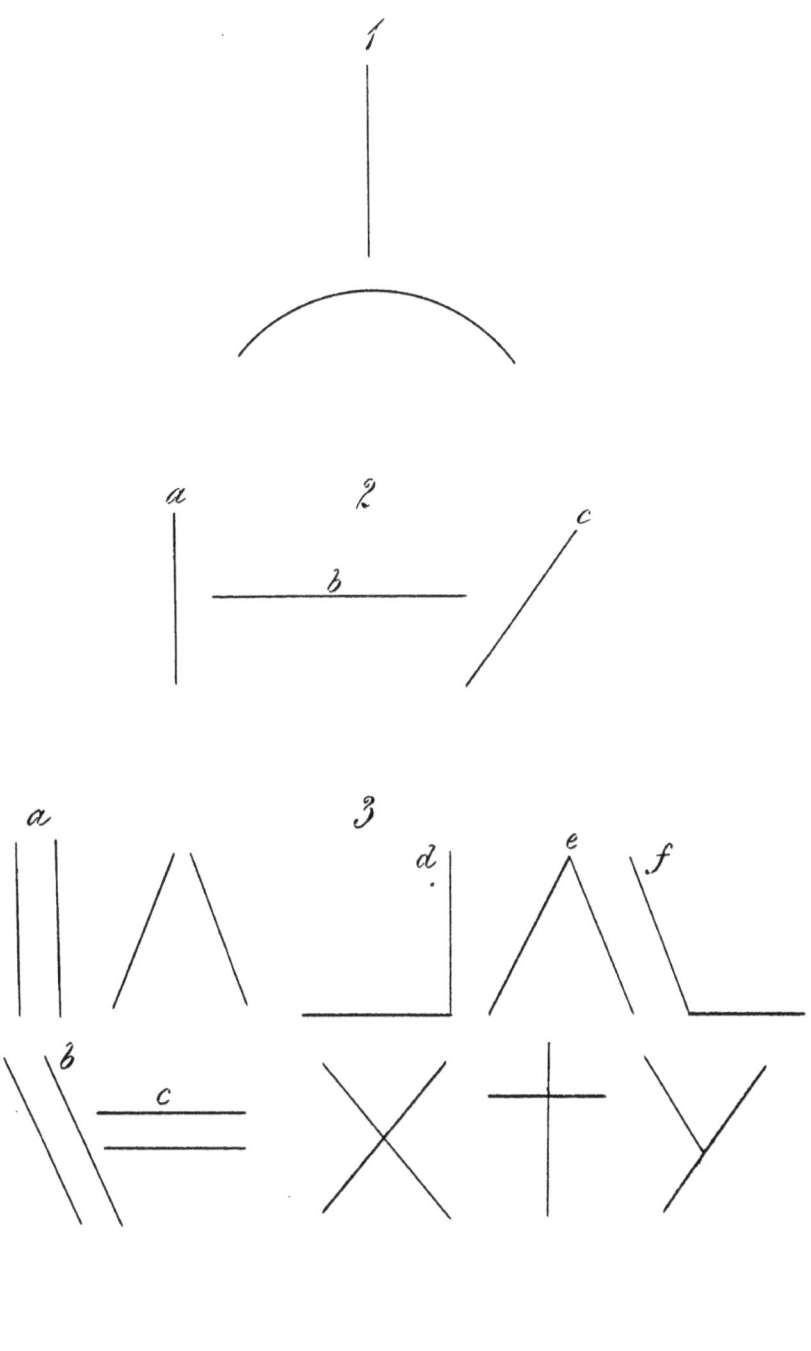

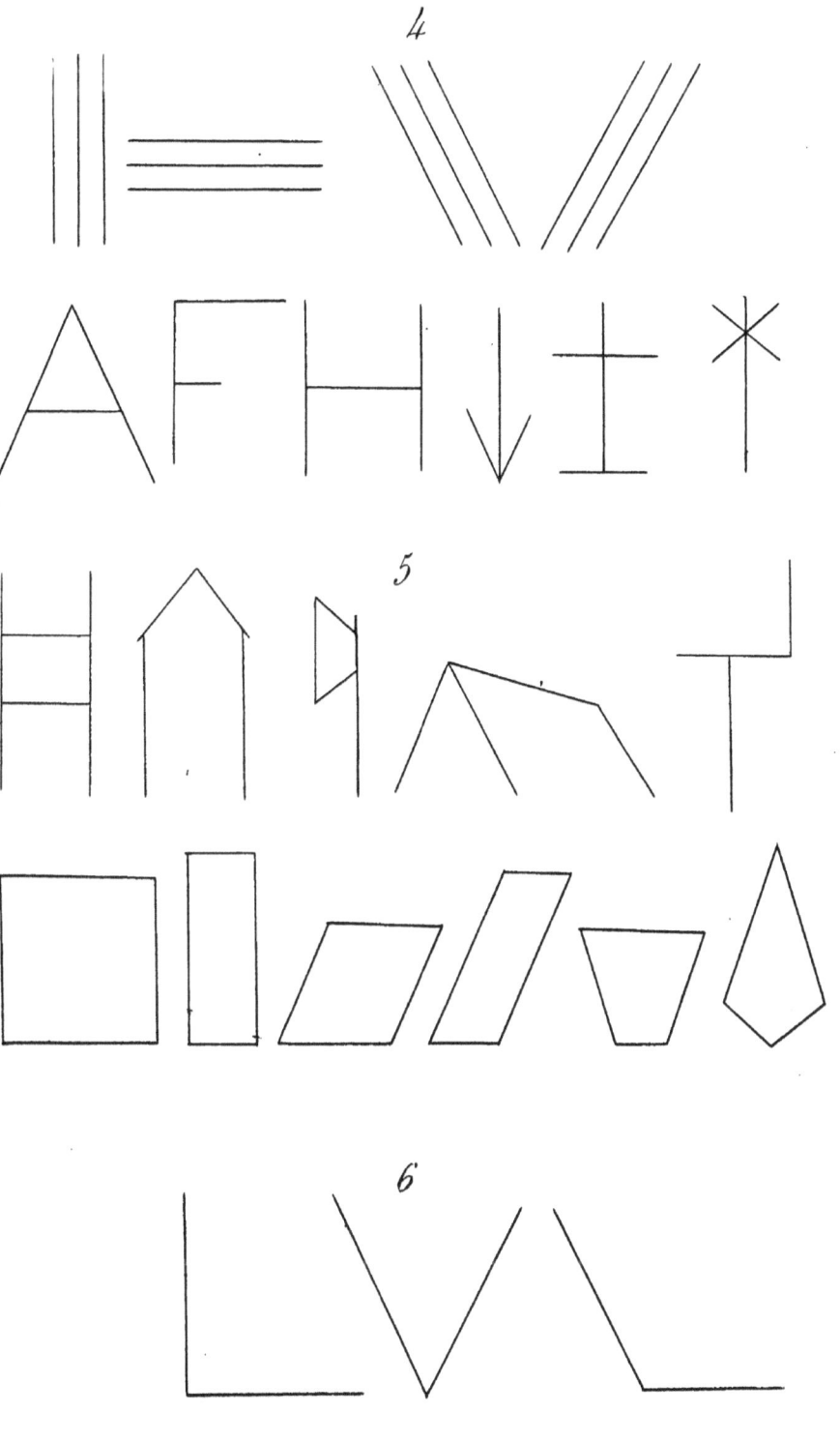

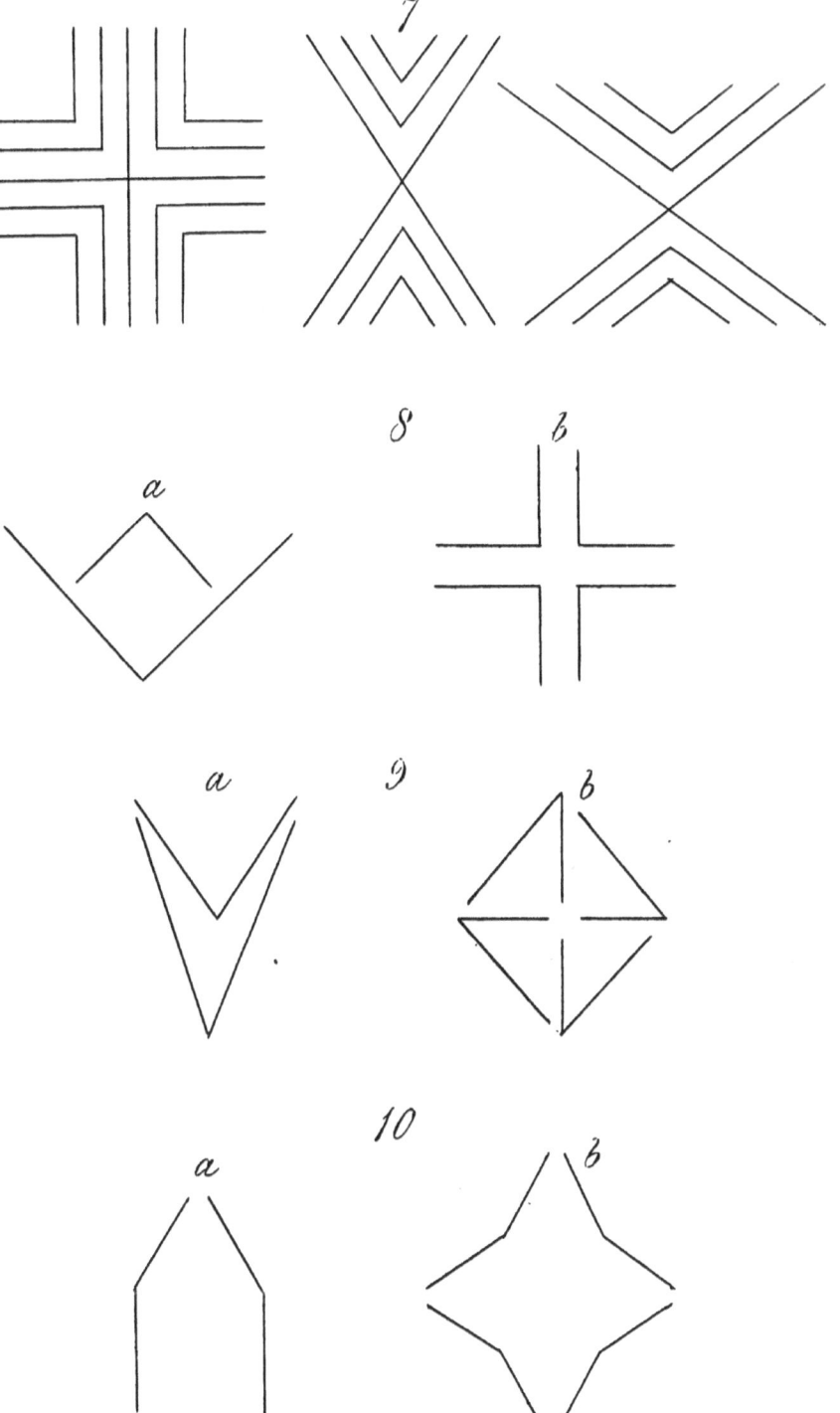

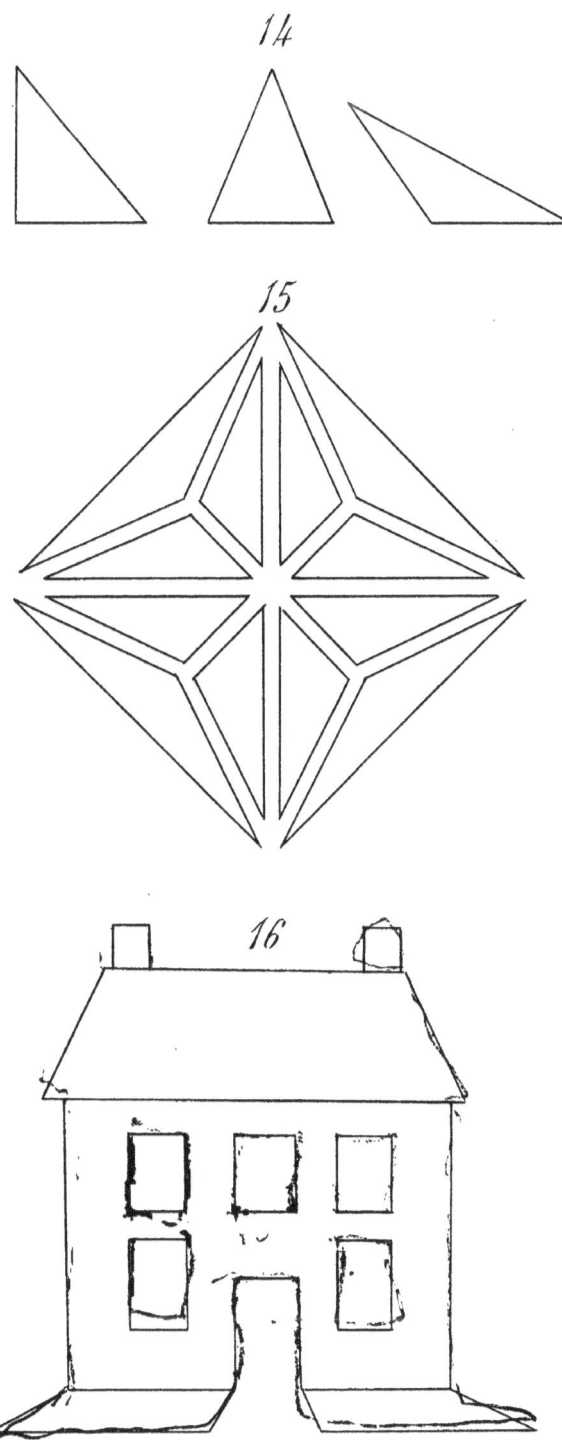

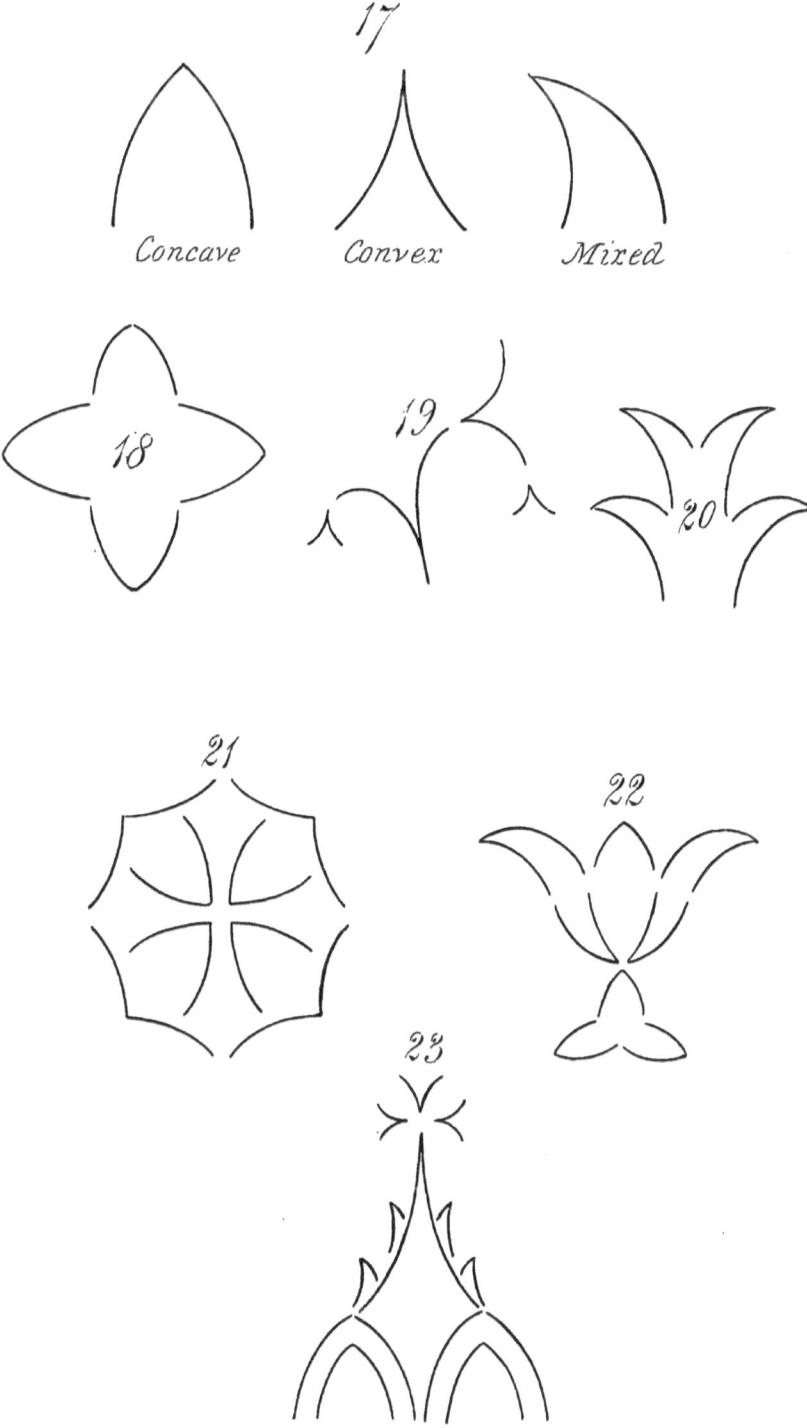

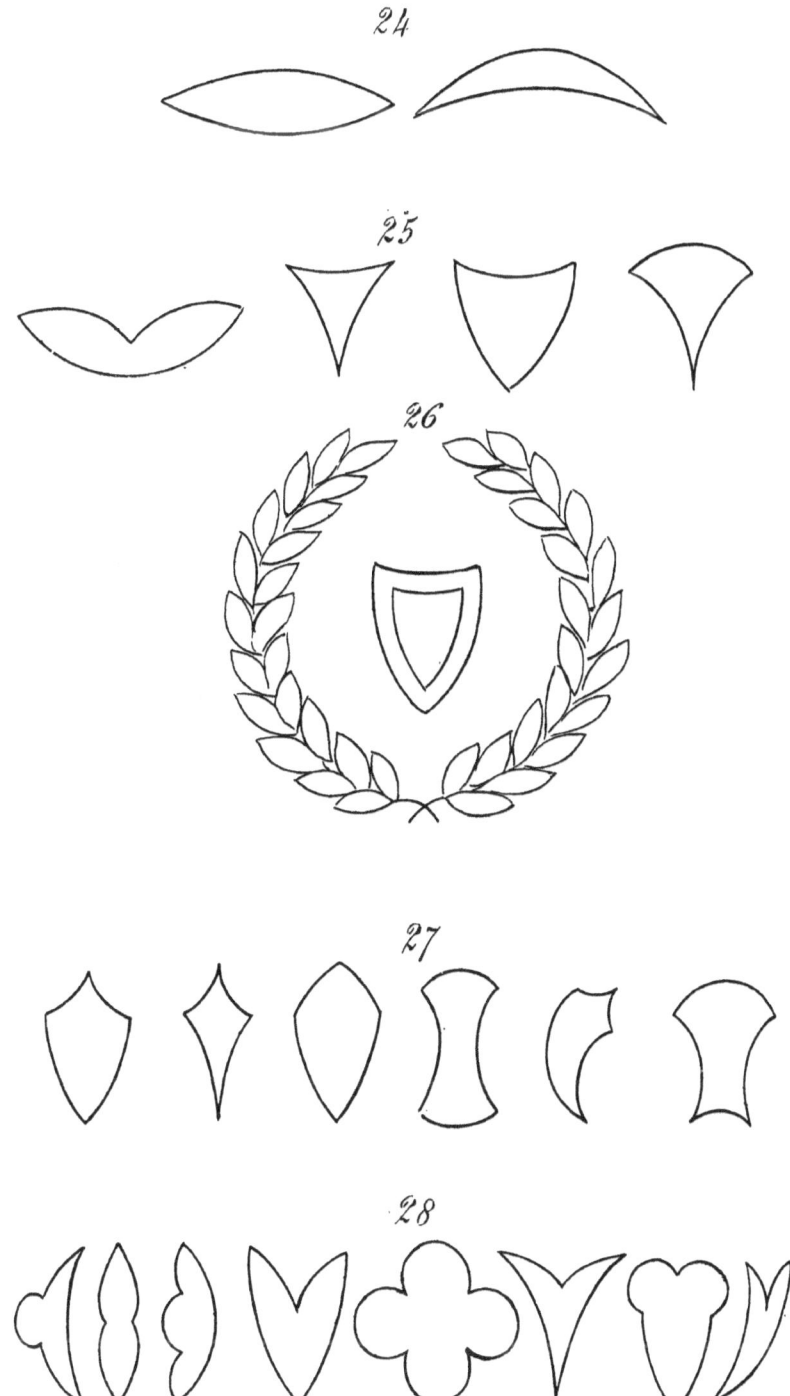

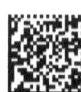
www.ingramcontent.com/pod-product-compliance
Lightning Source LLC
Chambersburg PA
CBHW020712180526
45163CB00008B/3053